Copyright © David A. Smith (Weef) 2015

The rights of David A. Smith (Weef) to be identified as the author of this work have been asserted by him in accordance with the Copyright, Design and Patents Act 1988.

This book is sold subject to the condition that it shall not by way of trade or otherwise, be lent, resold, hired out, or otherwise be circulated without the publisher's prior consent in any form of binding or cover other than that which it is published and without a similar condition including this condition being imposed on the subsequent purchaser.

A CIP catalogue record for this book is available from the British Library.

OAKLAND HOUSE PUBLISHING

Published by Oakland House Publishing
Flat 1 Oakland House, South Road,
London SE23 2UF

In a museum lived a painting called 'Black Square'.
It was painted in 1915 by the Russian artist Kazimir Malevich.
It had hung peacefully for a long time.

Until one day The Black Square decided he was bored.
He had had enough of being square.

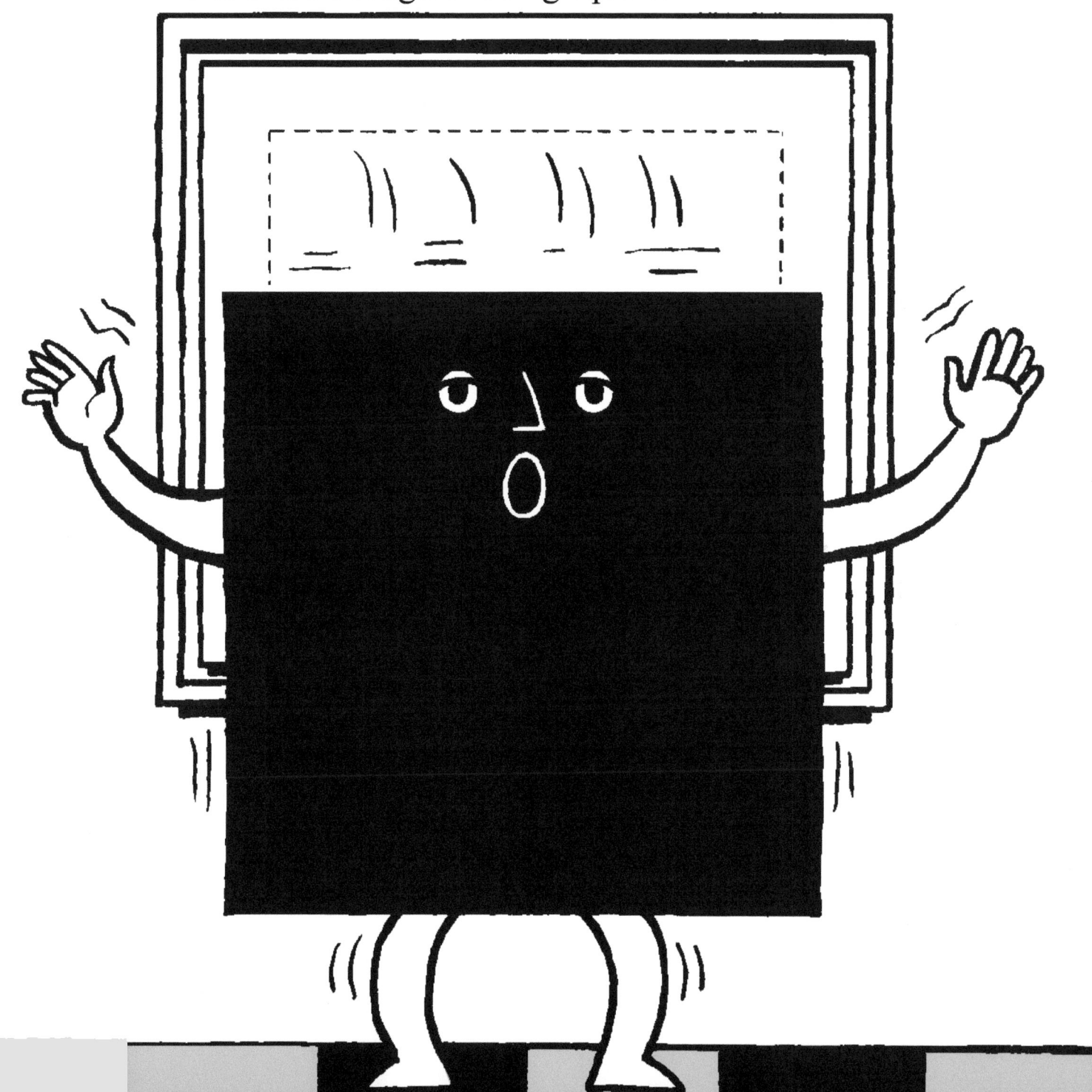

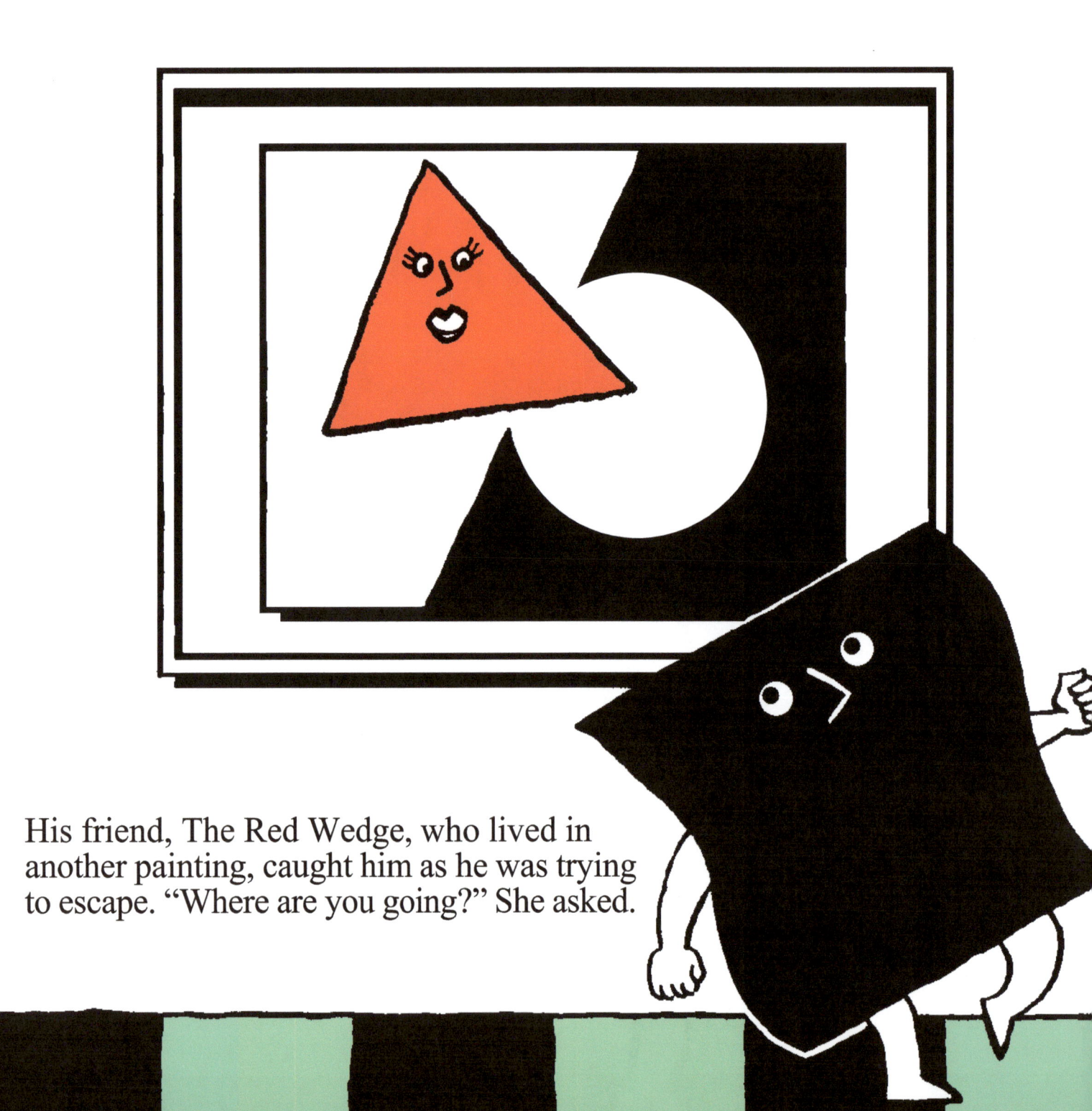

His friend, The Red Wedge, who lived in another painting, caught him as he was trying to escape. "Where are you going?" She asked.

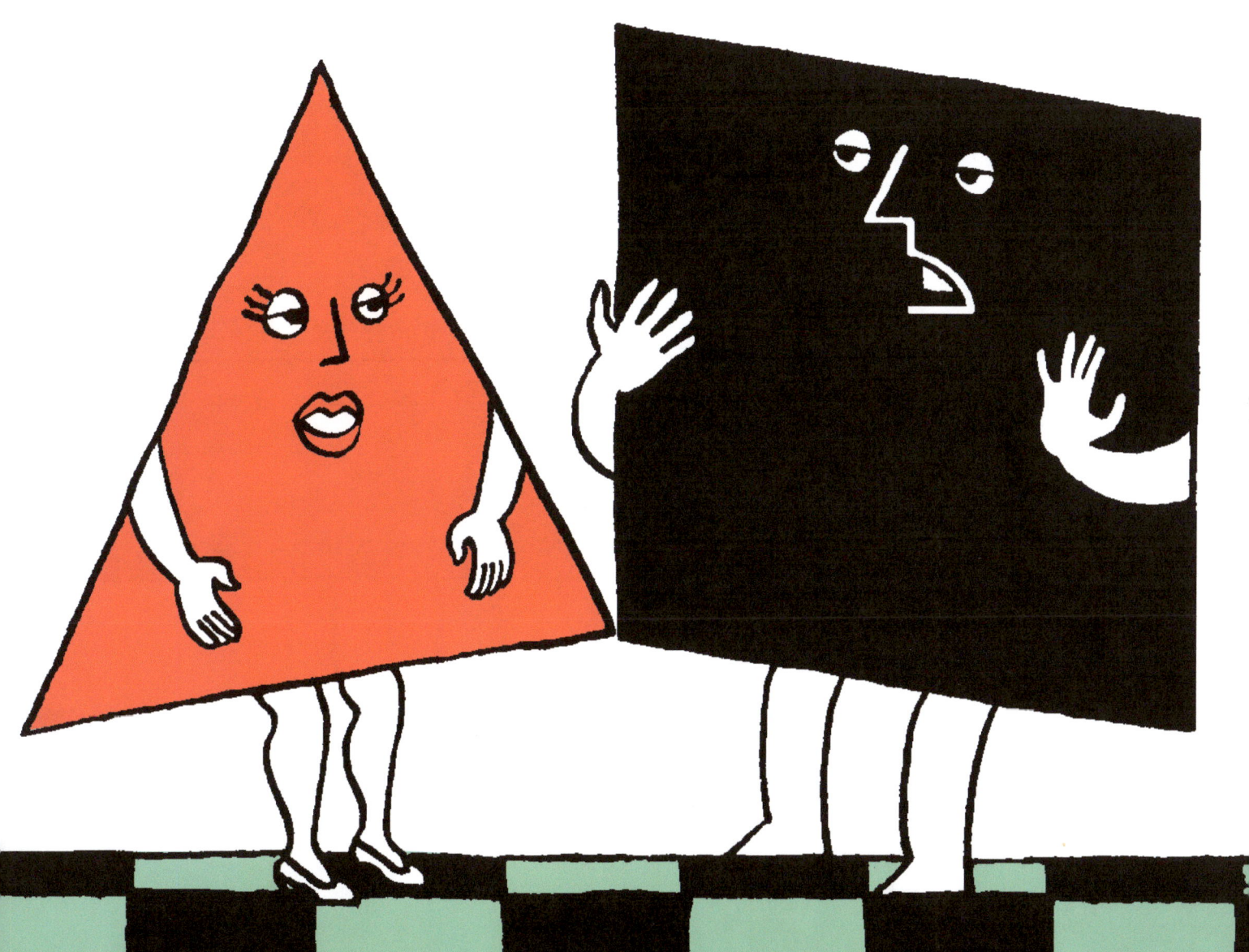

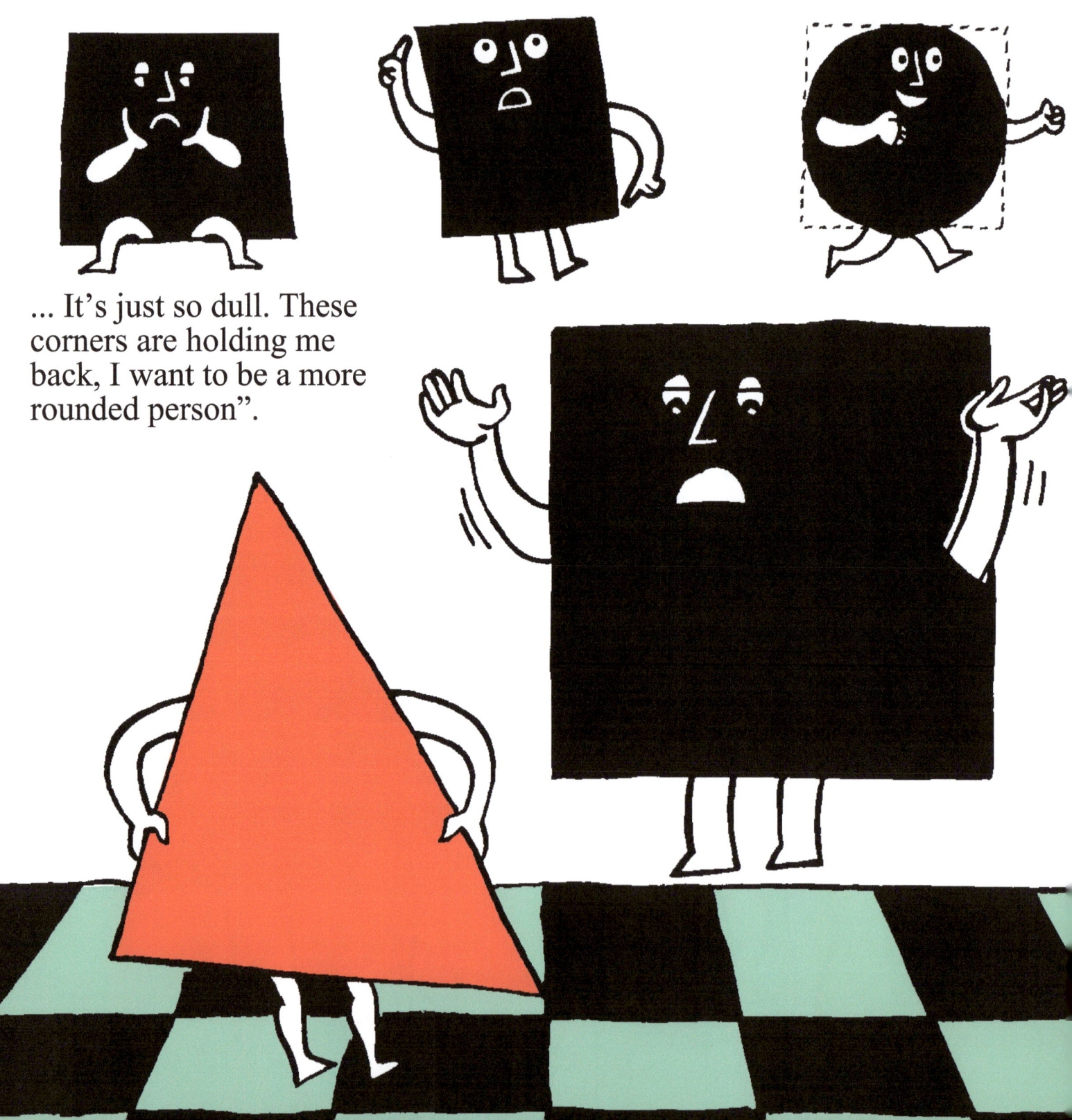

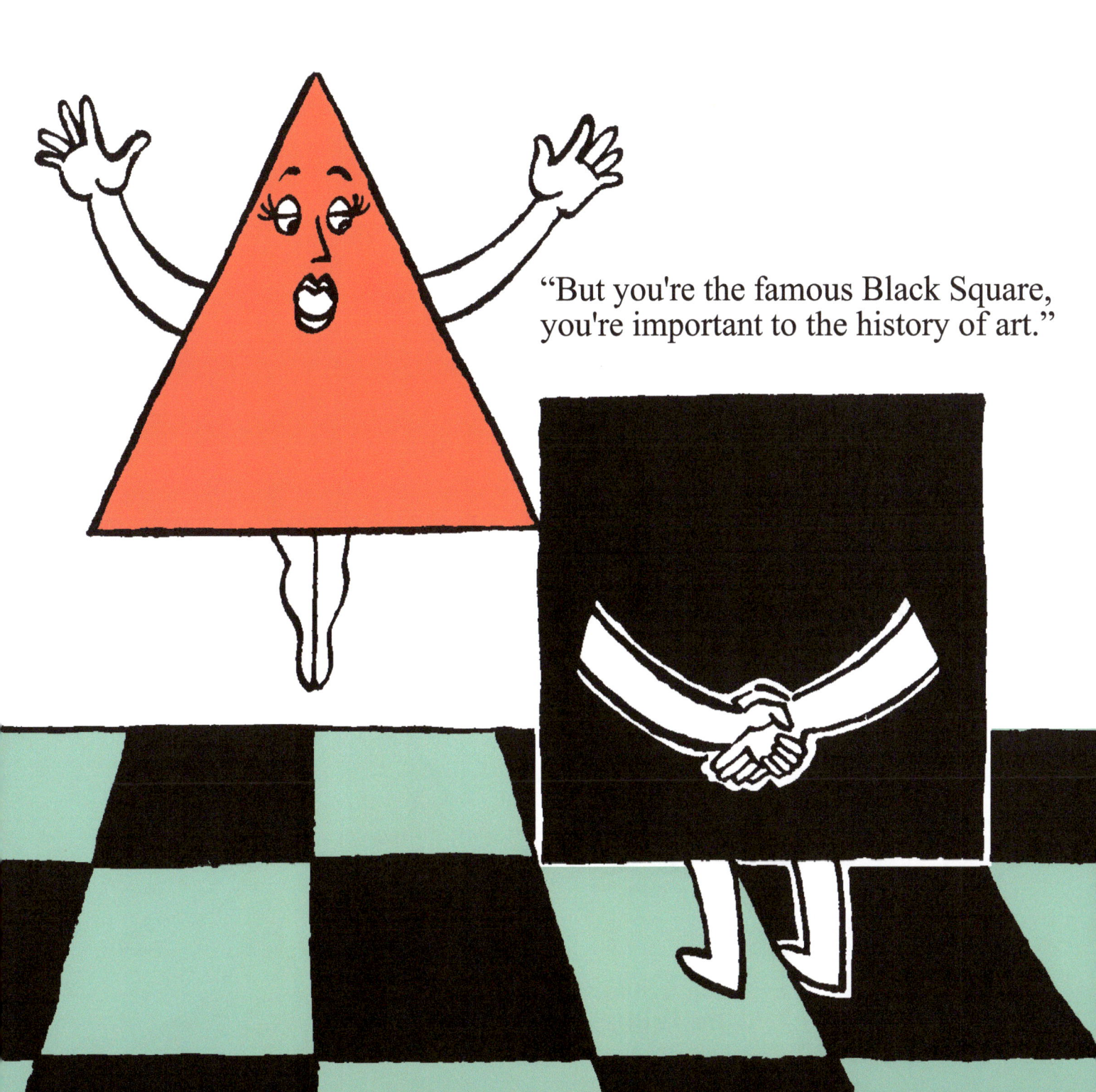

...you can be an right-angle triangle...

"I know – but it's so boring! At least your life's interesting.

...a scalene and you're the brilliant Red Wedge.

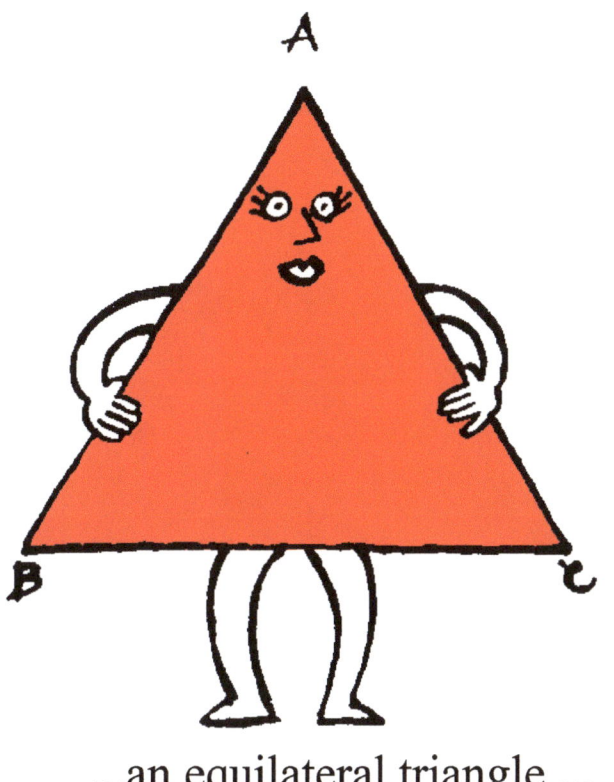

...an equilateral triangle...

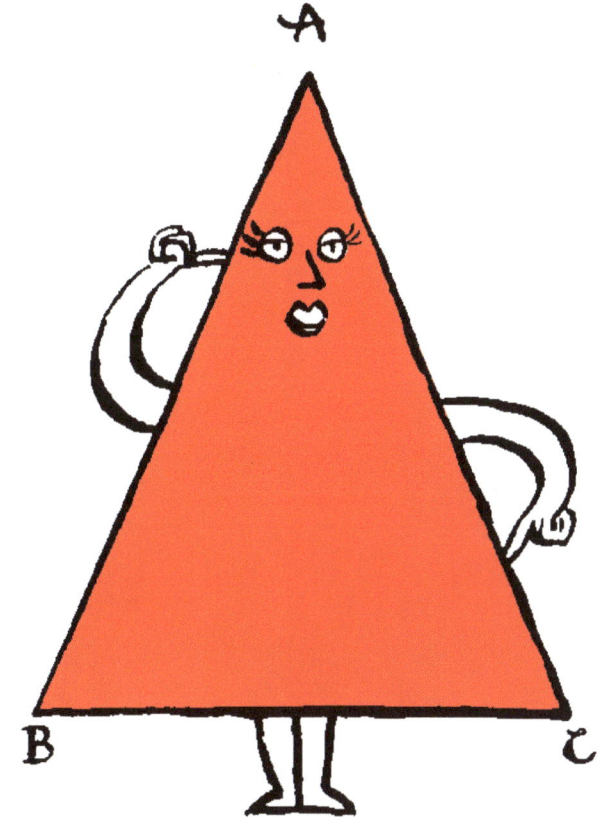

...an isosceles triangle...

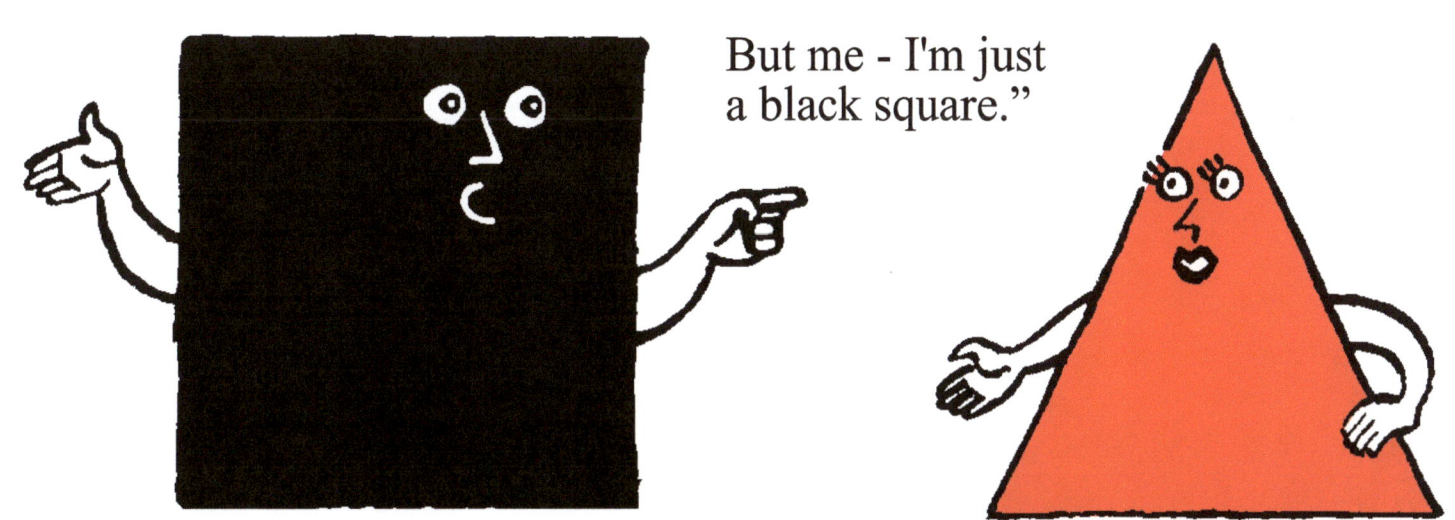

But me - I'm just a black square."

"I could take you to meet someone who might be able to help you. It's a long way and he's not very nice. But he is round."

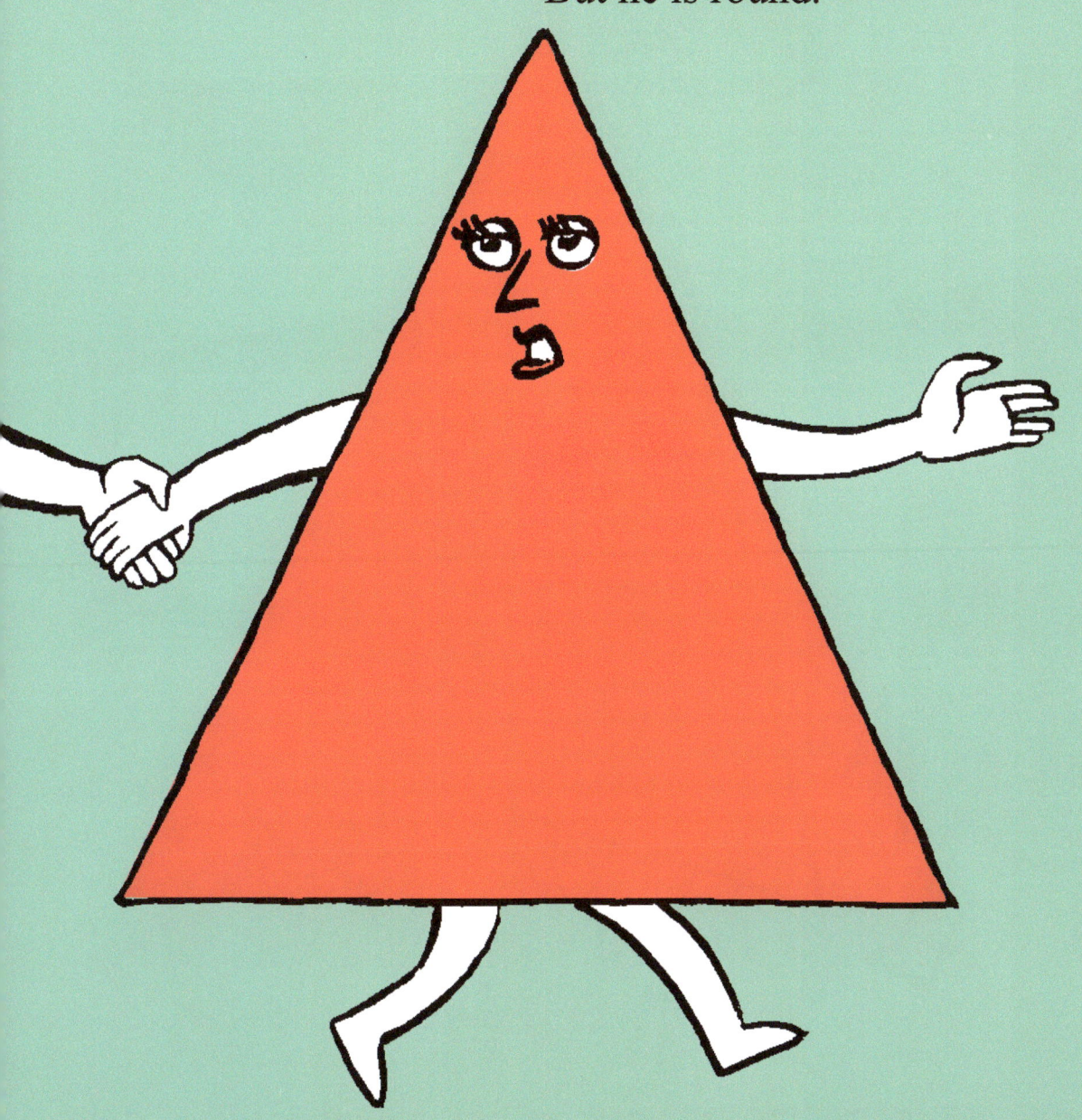

The Black Square got very excited as they set off through the land of signs.

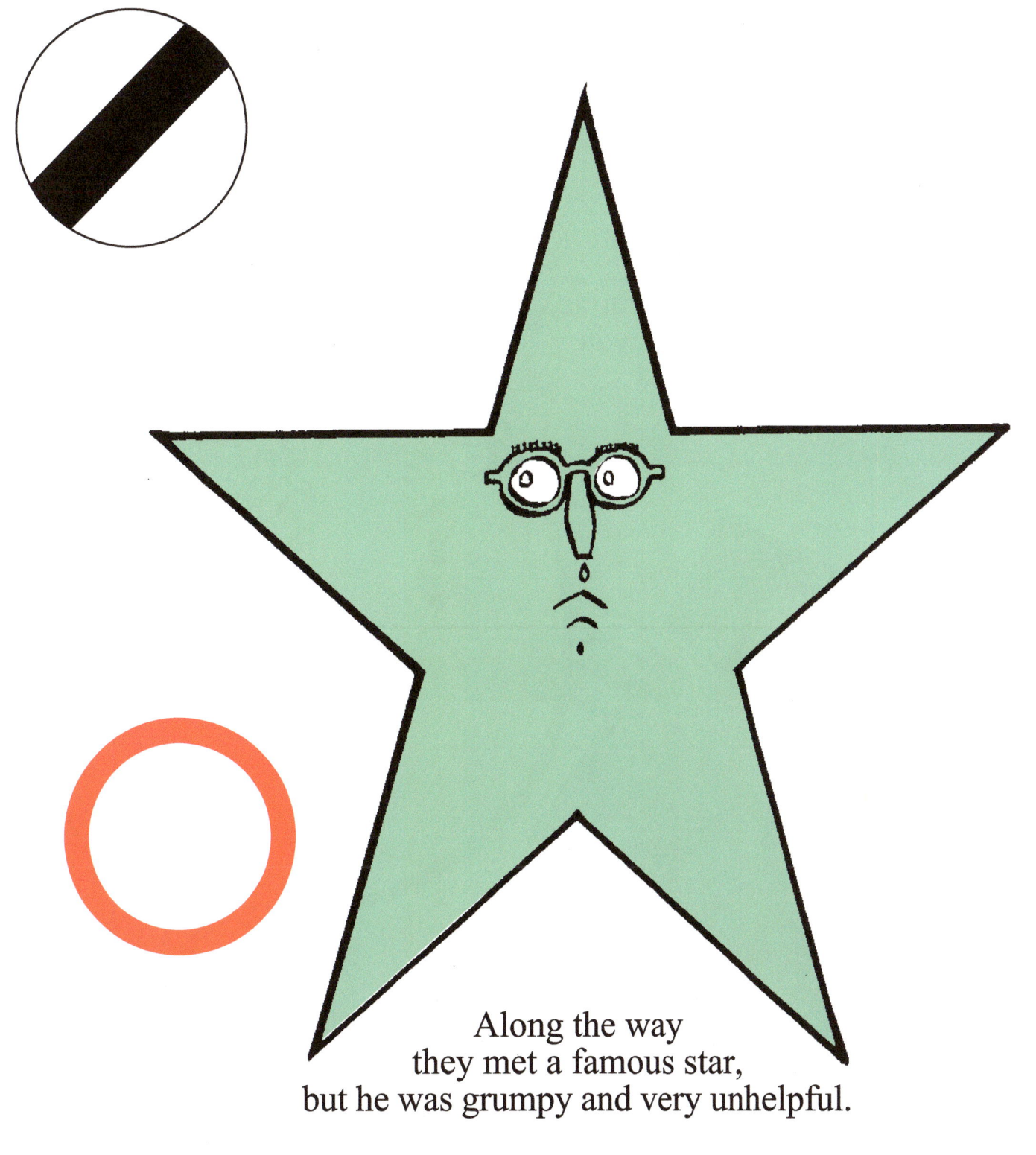

Eventually they found The Circle. "What do you want? Can't you see I'm busy." He snapped.

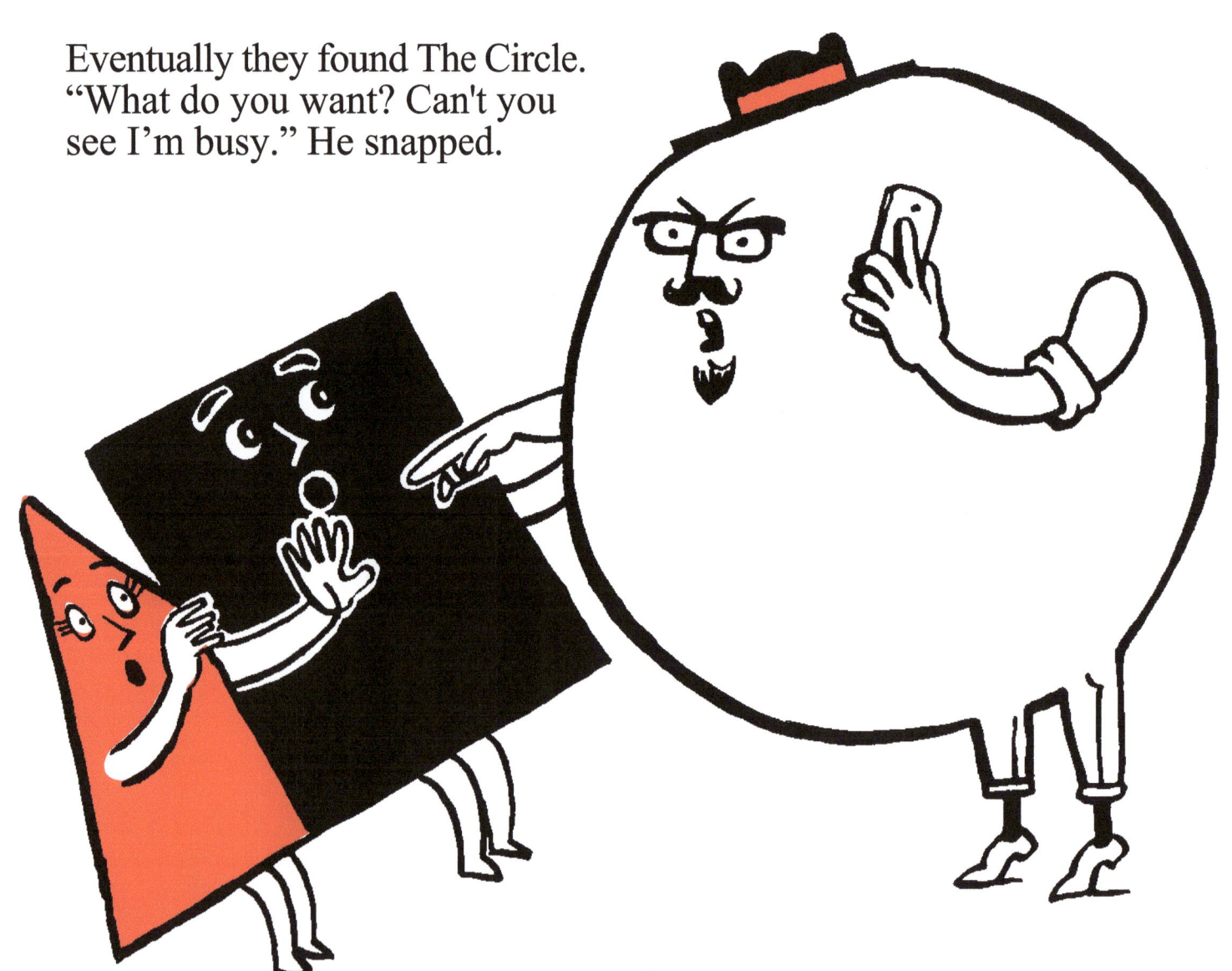

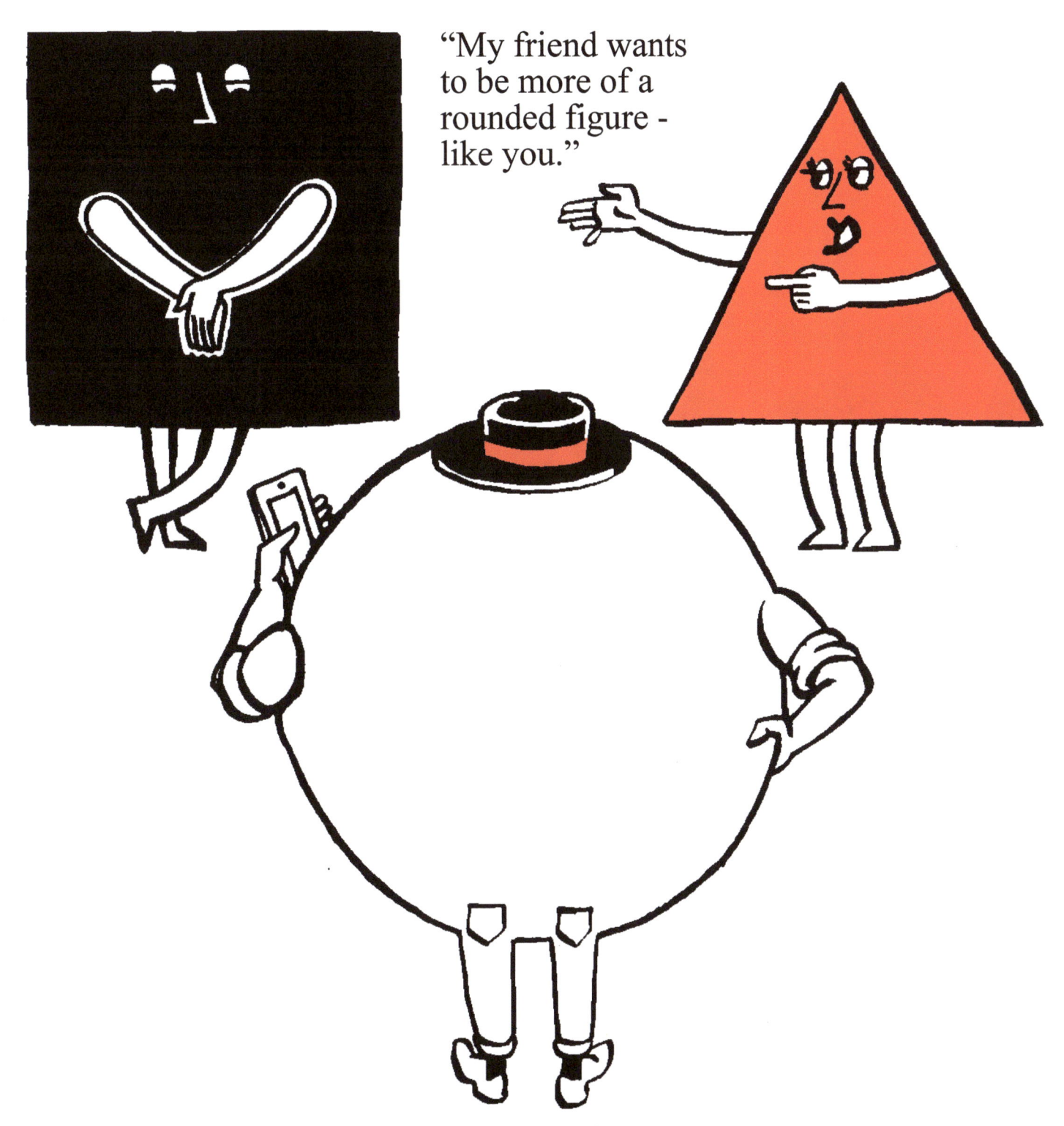

"The first thing we can do," said the Circle, "is cut off some of those rough edges."

"No! Not like that!" They both cried.

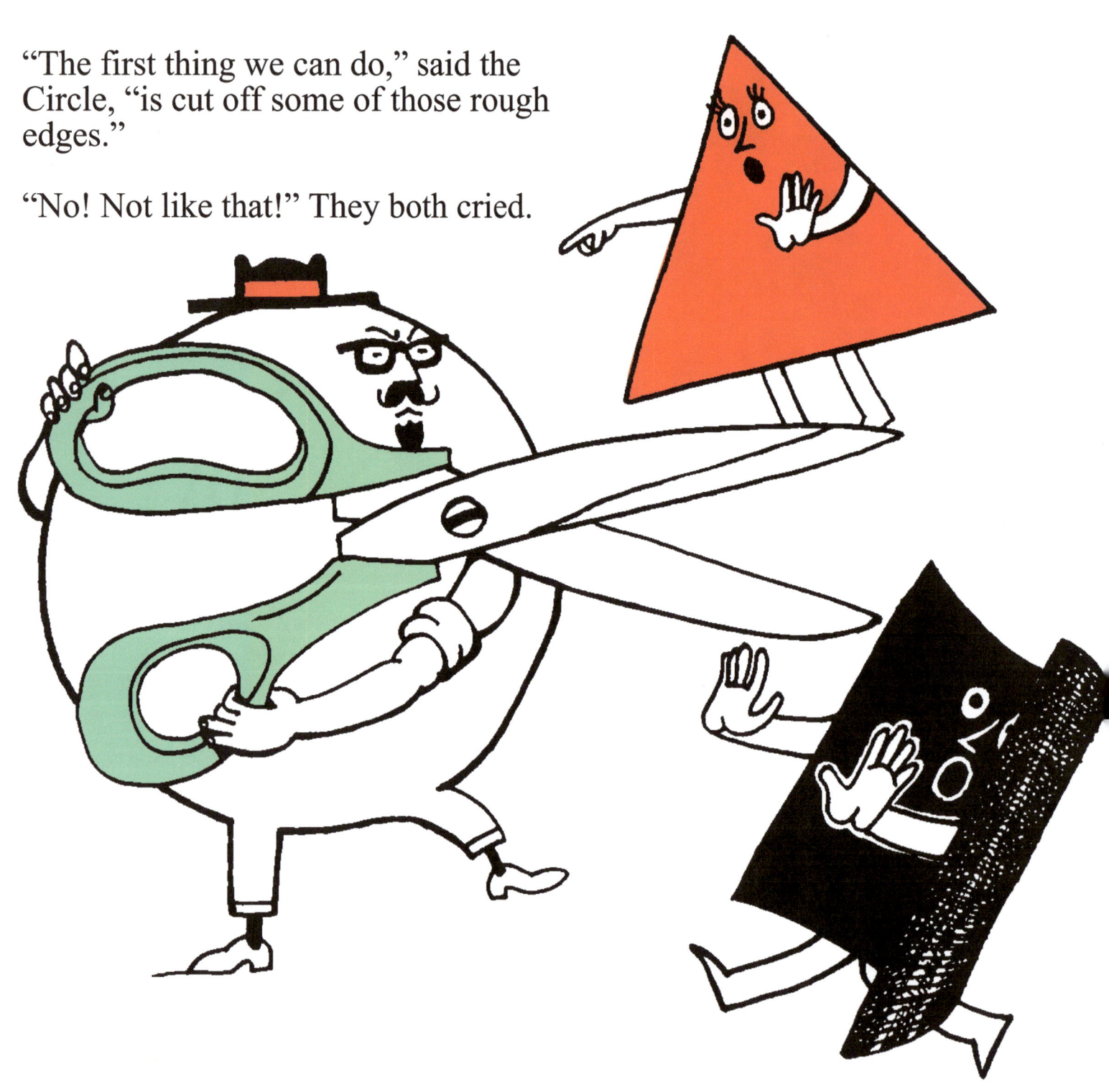

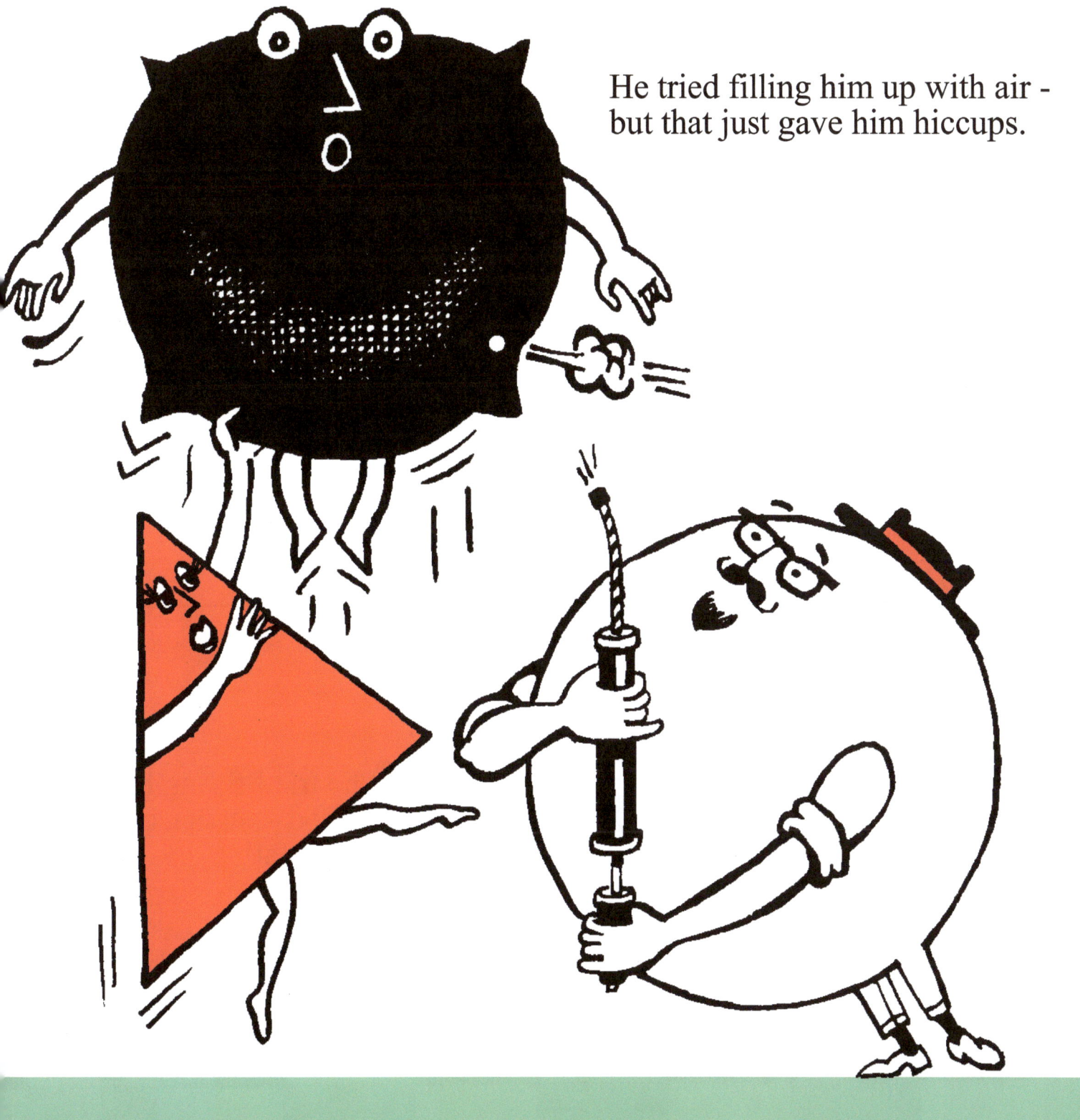

He tried filling him up with air - but that just gave him hiccups.

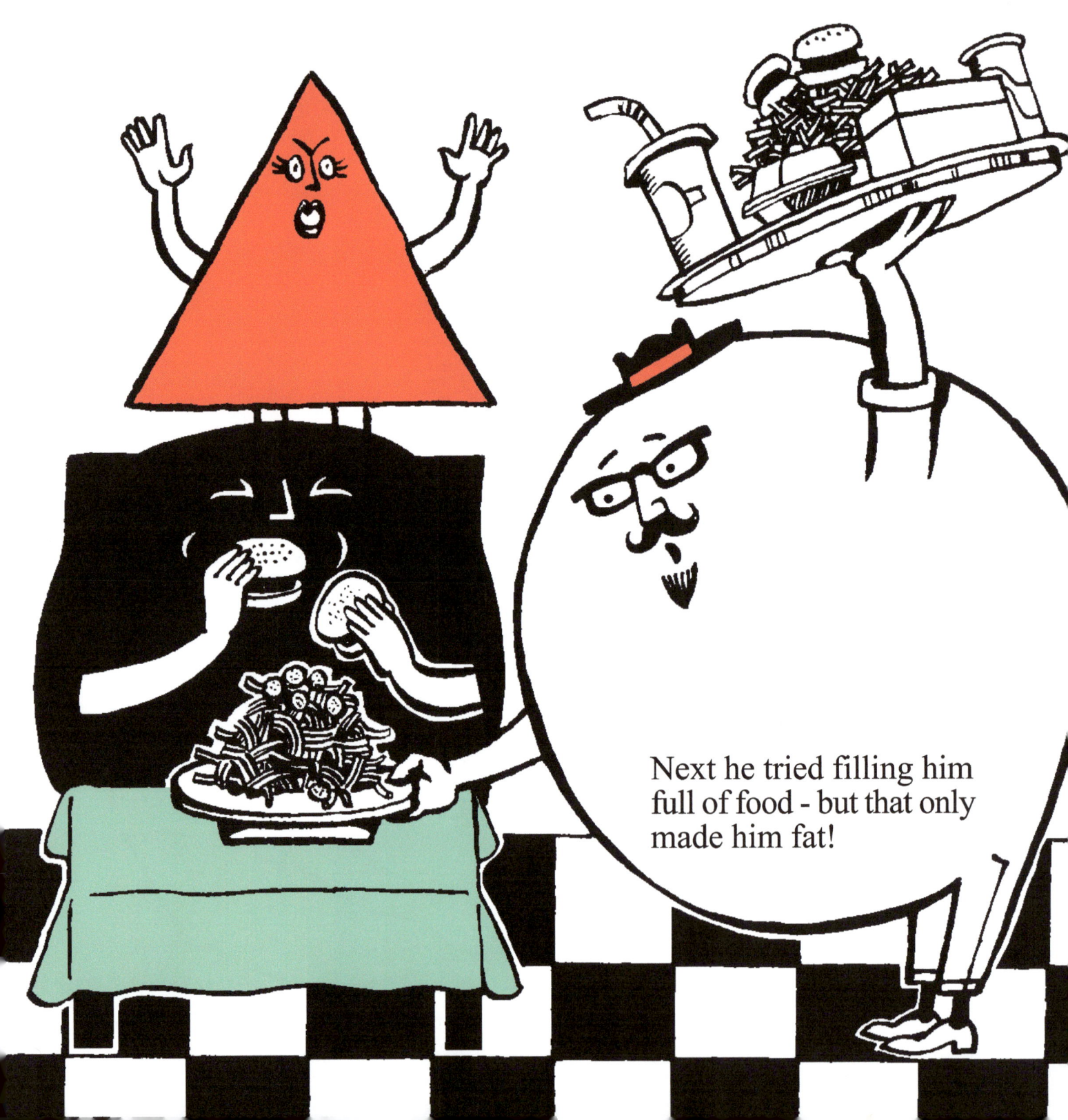

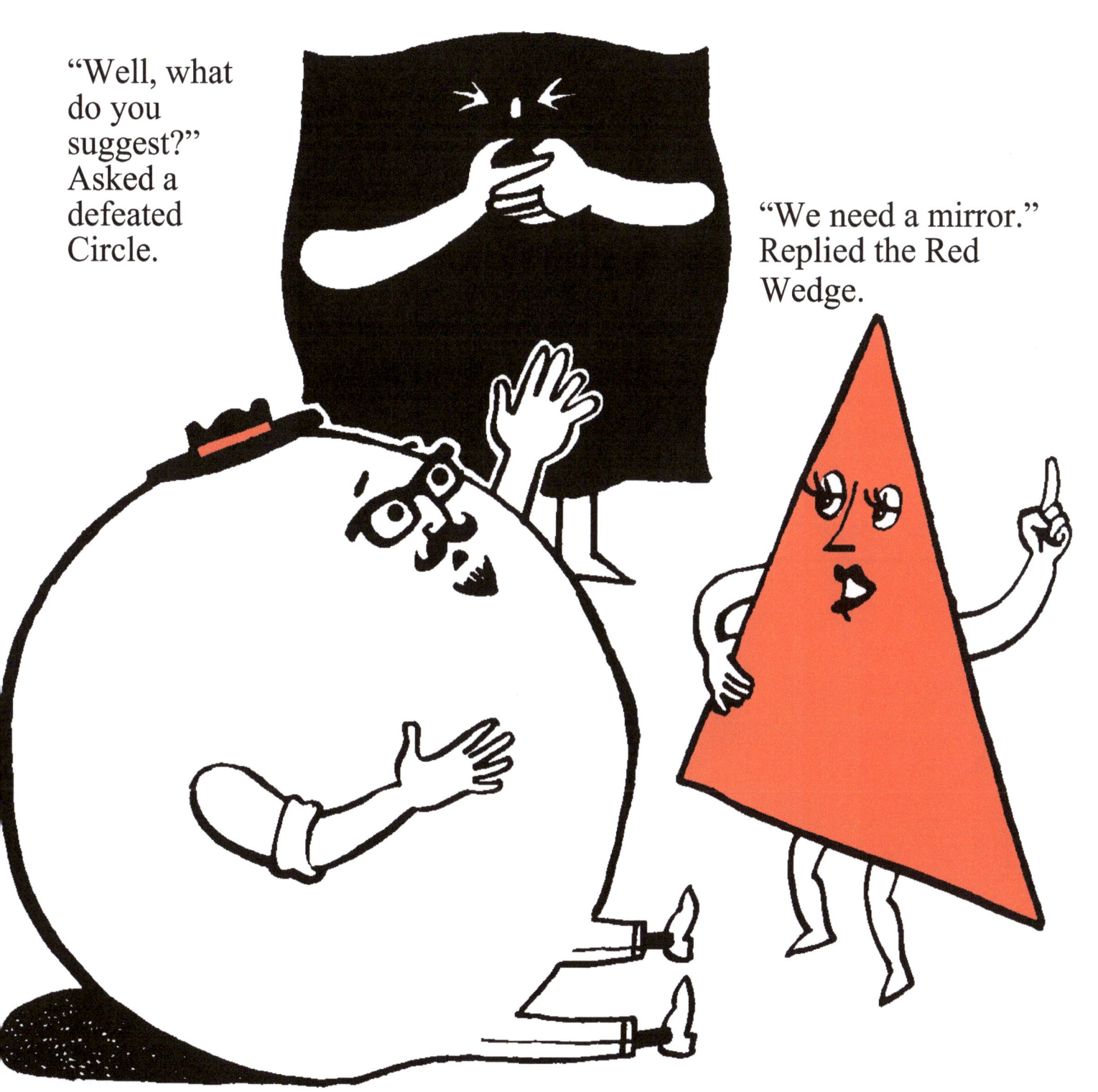

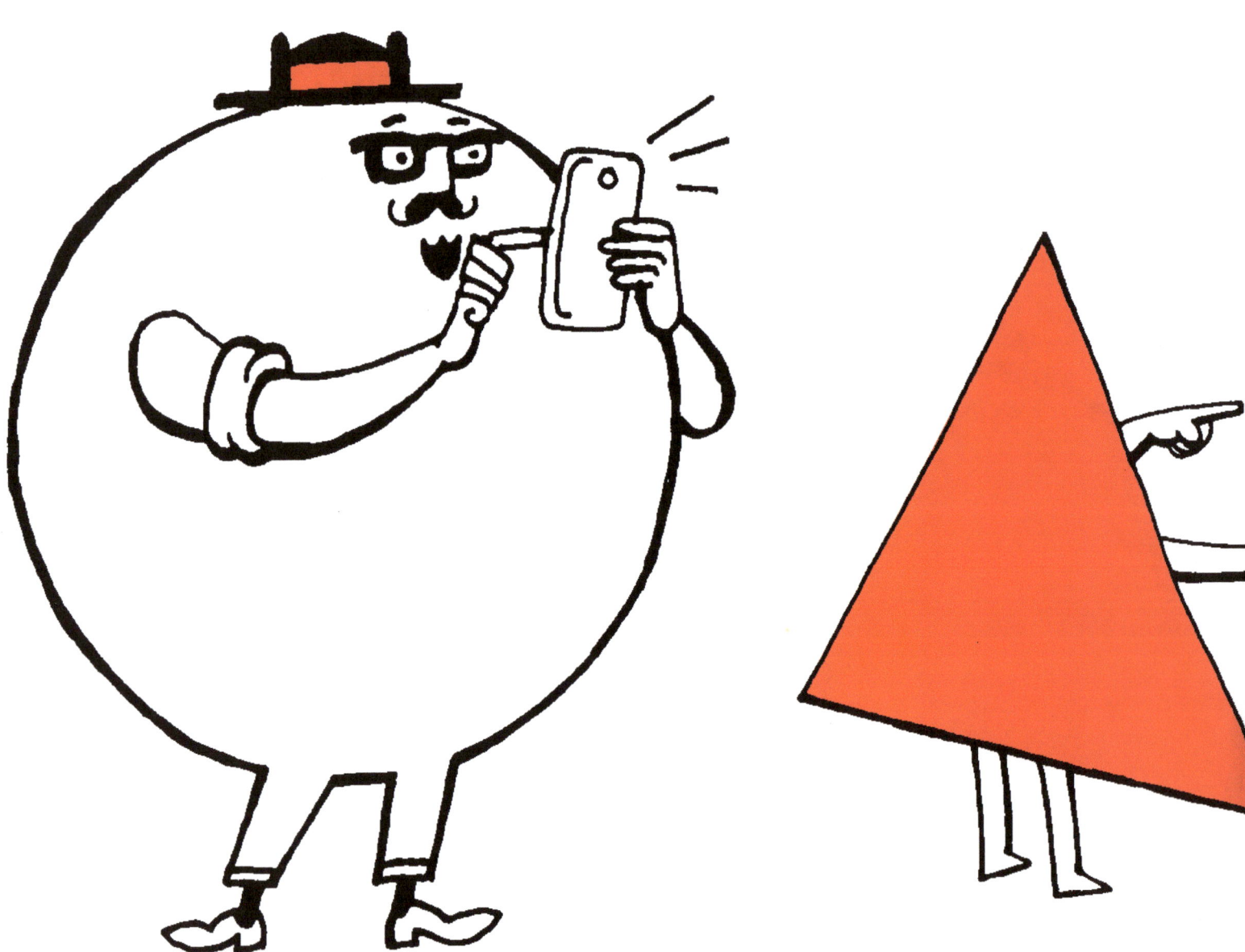

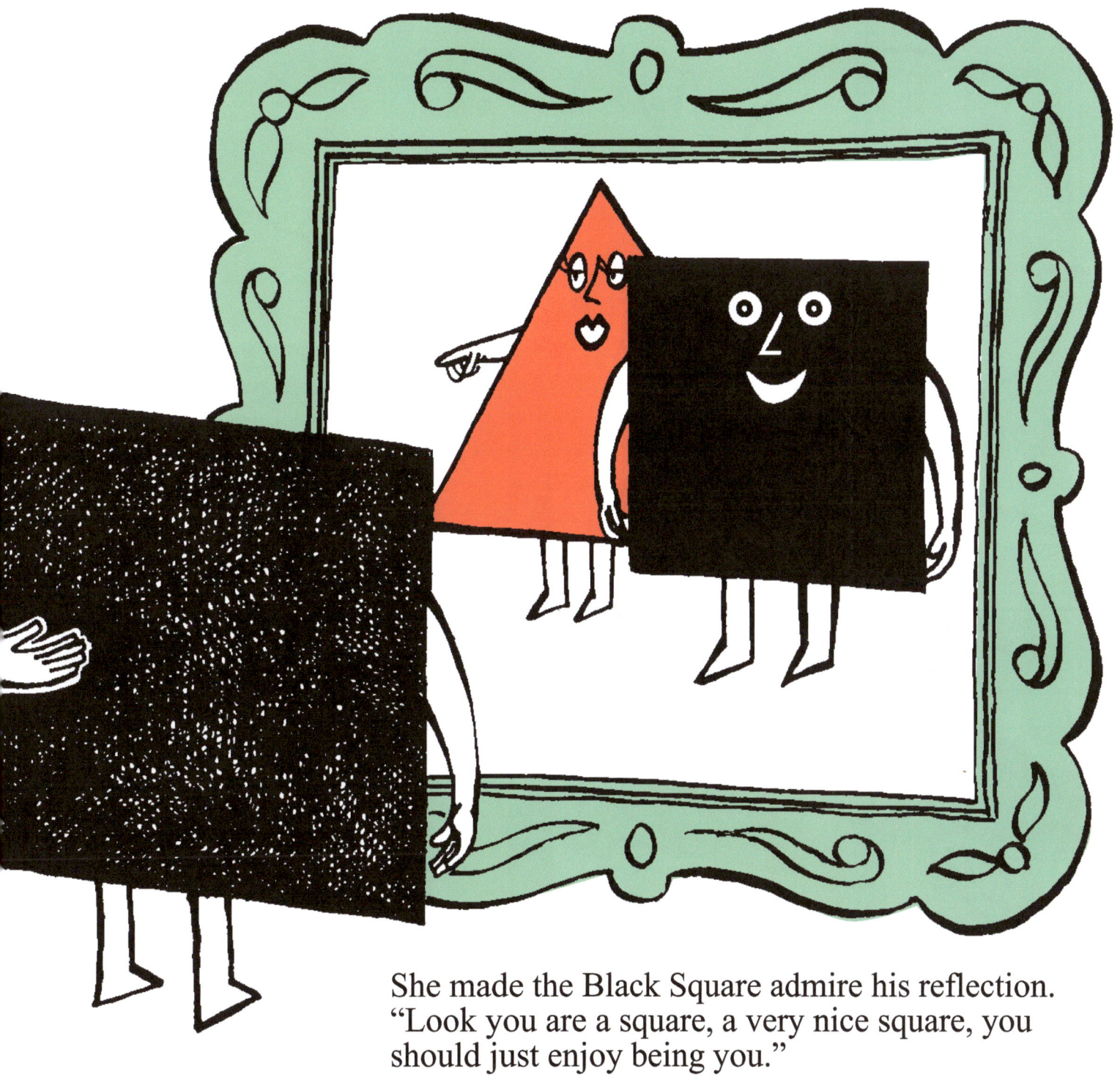

She made the Black Square admire his reflection. "Look you are a square, a very nice square, you should just enjoy being you."

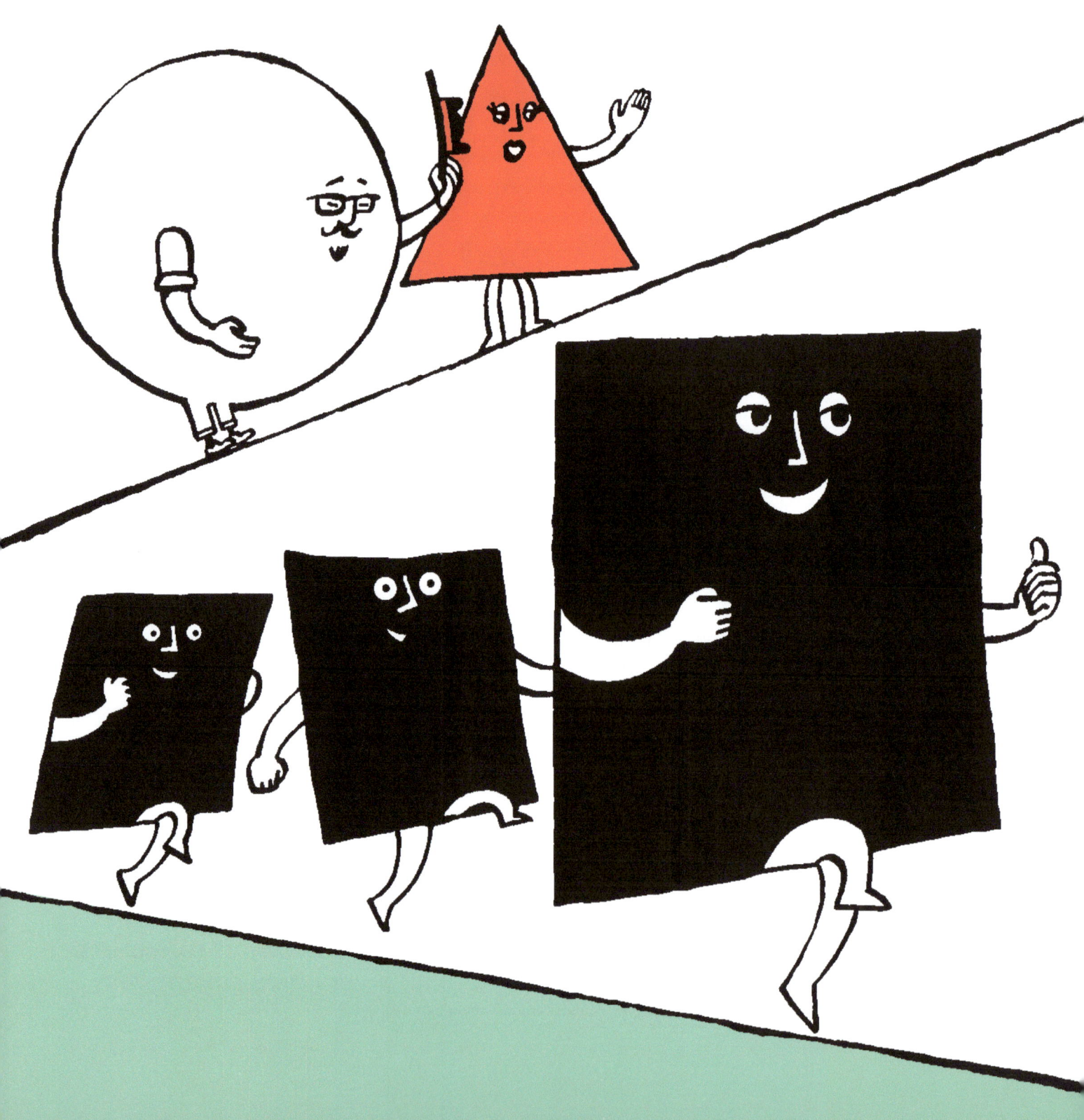

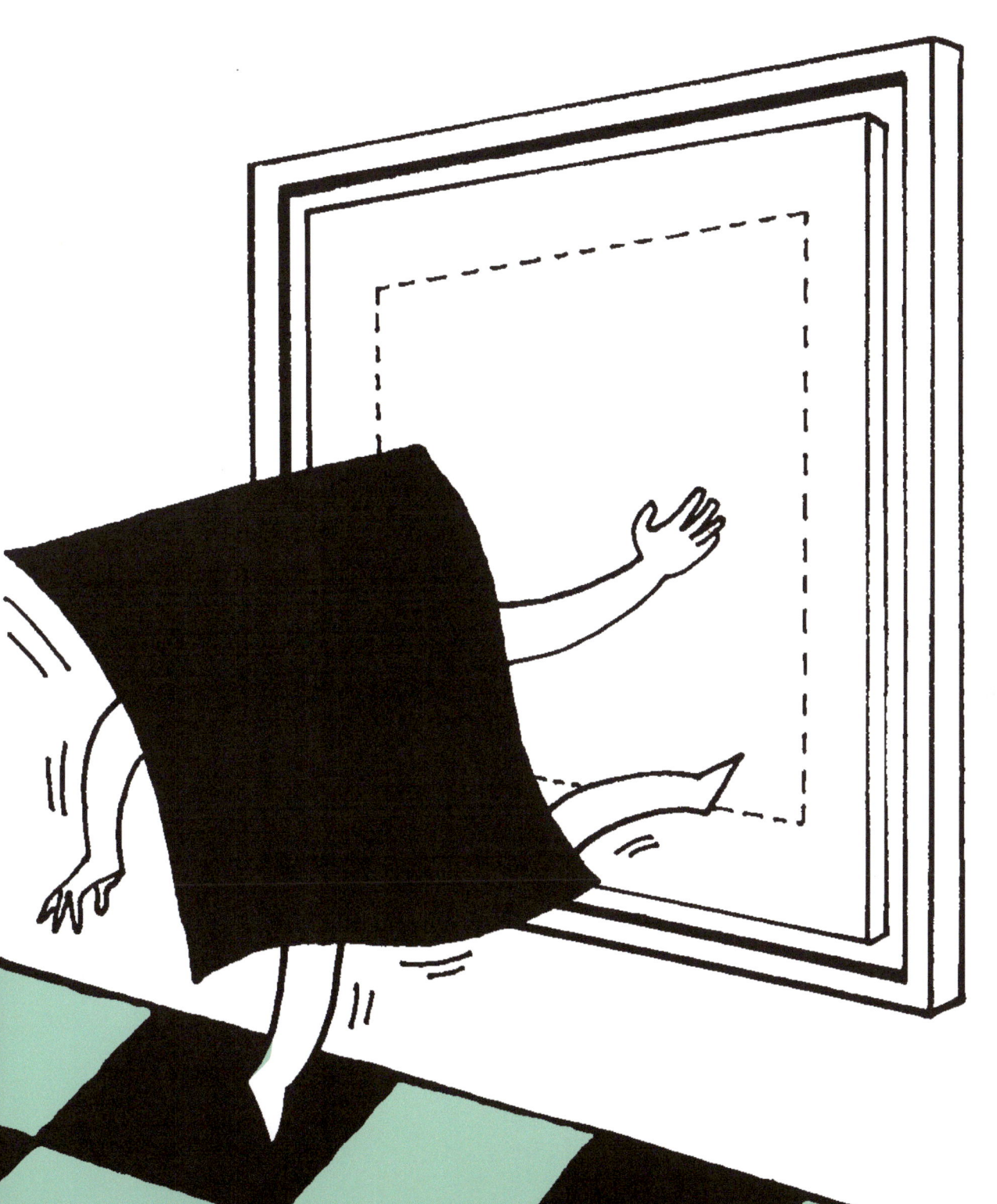

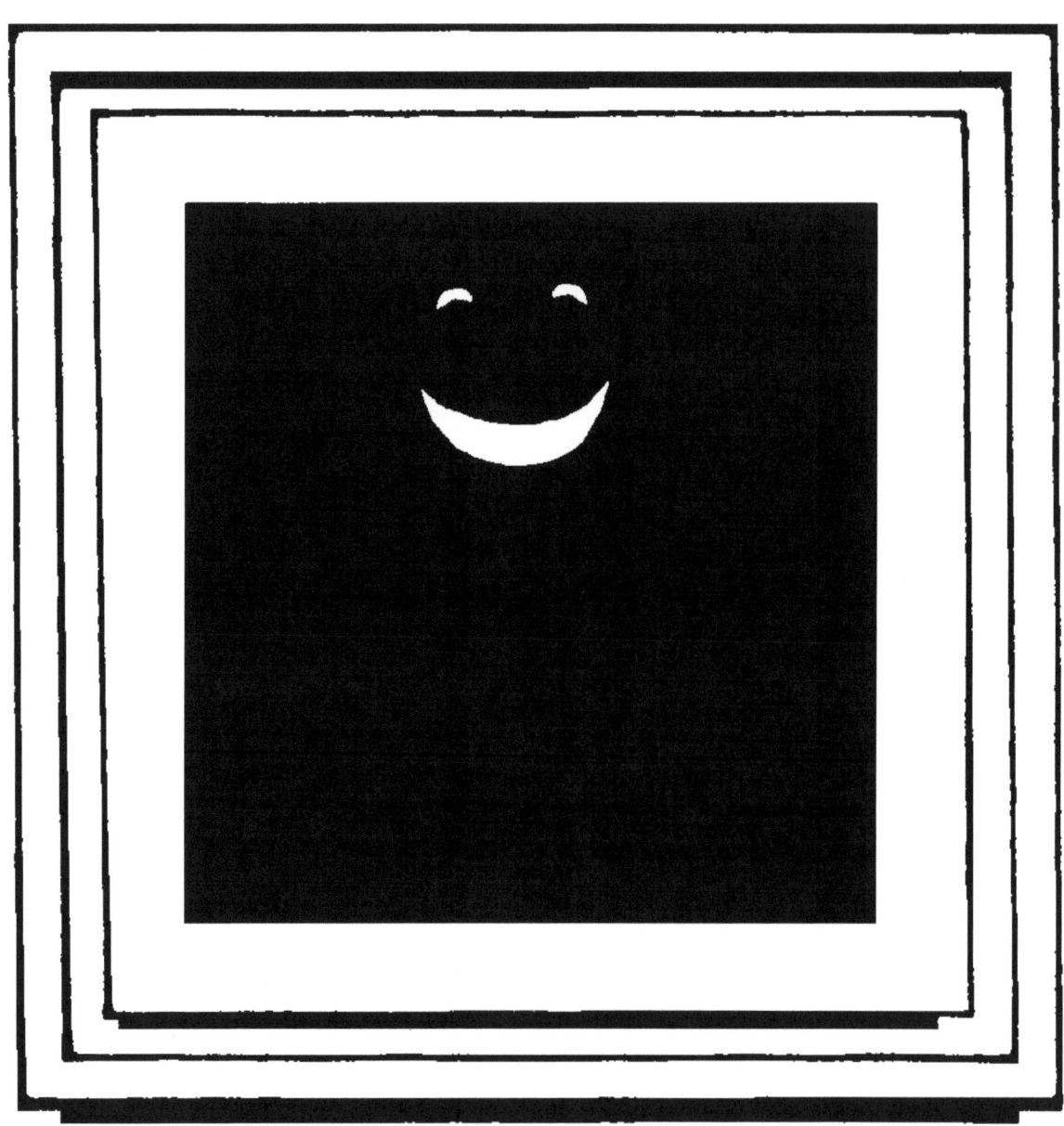

www.ingramcontent.com/pod-product-compliance
Lightning Source LLC
Chambersburg PA
CBHW041304180526
45172CB00003B/961